CONFESSIONS OF A EX DOOFUS ITCHY FOOTED MUTHA

ART DIRECTION & STORY BY

MELVIN VAN PEEBLES

ILLUSTRATIONS BY

CAKTUZ TREE..?[13]

AKASHIC BOOKS

This is a work of fiction. All names, characters, places, and incidents are the product of the author's imagination. Any resemblance to real events or persons, living or dead, is entirely coincidental.

Published by Akashic Books
Inspiration for the film *Confessions of a Ex-Doofus-ItchyFooted Mutha* by Melvin Van Peebles
©2009 Melvin Van Peebles

ISBN-13: 978-1-933354-86-6
Library of Congress Control Number: 2009922931

First printing

Akashic Books
PO Box 1456
New York, NY 10009
info@akashicbooks.com
www.akashicbooks.com

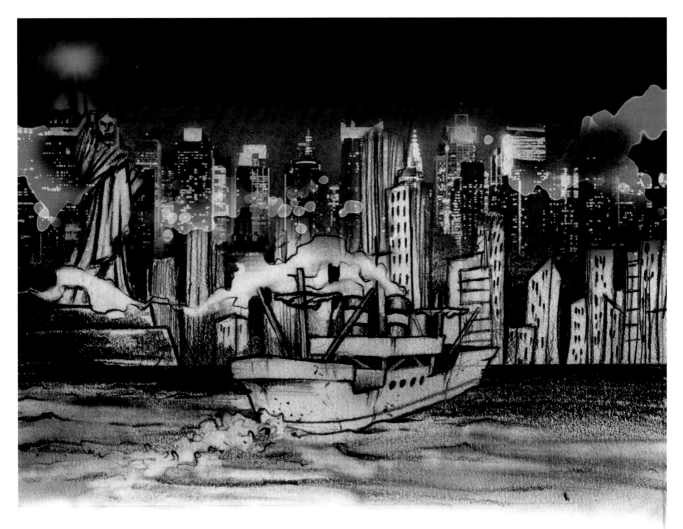

PROLOGUE

Go...go go that's all I knew
Why? I don't know

All I knew was I had this urge to get into the wind...
I couldn't get it out of my system back then.
I wanted to see all there was to be seen...
Chicago in the rearview mirror was my big dream.

Anyhow a coupla of days ago I finally managed to drag my sorry
stowaway ass back here,
to the Apple again.

F.Y.I....Making your own bed aint a guarantee it's gonna be comfortable.

Take me...At first glance, to a casual observer,
Me, sitting down here sipping my forty of beer all dressed up...
Me, looking like the world is my oyster, looking like I got it made
Me, clean as the board of health, clean as a Texas chitlin'
Me...But, on the other hand, I could be...Well
...Like they say, "Tell the truth and shame the Devil"...
I could be a textbook case of a brother trying to work some liquid courage up
...Lots of slips between the cup and the lip...lots of them
But it's not a question of nerve...
Okay...So what's the holdup then?
Here I am, sharp as a rat's turd,
Which is, a well-documented fact, sharp on both ends.
Here I am sitting under her doorstep.
The Deacon, like I just heard, is out the picture
I'm not stalling...it's just that it takes time
...Maybe she has forgotten all about me...
You know, to figure out the best way to approach a situation
One needs time to polish one's approach to a situation
After that...Well I got a finger and she's got a buzzer
If the buzzer don't work...I got knuckles and she got a door
I just need to catch my breath a few seconds more
A little extra contemplation never hurt a bit.
Heaven knows, Hell too...Hearts aren't something to be toyed with.

When I was born,
a stork flew over the zoo fence
Did a 360 and began to climb into the sky
He kept climbing until he reached the outskirts of heaven.
An angel was standing with a diaper with me in it
The angel hooked the diaper over the stork's bill
The stork did a U-turn and made a B-line back to earth.
He flew through the hospital window
Where my mom was lying in the bed
He placed me in her waiting arms...
And that's how I was born,
At least, anyhow, according to my mom.
I even talked myself into believing
That I had heard the flap flap flap of the stork's wings...
I was one gullible son of a bitch because of that story,
Almost got me killed a couple of times...
If I had a fault that was it,

I was one dumb M.F....
It took me awhile to learn to watch my step...

My dad was a janitor,
but we didn't live in the basement,
we were on the third floor,
who could ask for more...Right?

Fact was that it was the apartment nobody wanted. Fact
was the elevated train passed so close It would come
bursting out the kitchen door and tear ass down the hall.
No lie, you could damn near reach out the window and
touch the railroad ties. You got used to it...but the one thing
I couldn't get used to though was the movies, the Saturday
matinee triple feature.
When I was little, I was little...I was the runt of the litter
and therefore, naturally, the designated punching bag.
You can get tired pretty quick
of always getting your ass kicked

...Besides, who wants to wait around until their muscles
grow in? The way they pounded on me on Saturday at the
matinee, there wasn't gonna be anything left but a grease
spot anyway.
You wouldn't think someone as adverse as me to getting the
hell kicked out of 'em would end up in some old
makeshift mud hut of a jail in some godforsaken
compound, waiting for dawn to get blown to hell by some
firing squad, not really...now would you?
Well thereby hangs a tale...A piece of one anyway...

As concerns getting my ass kicked on Saturdays
I came up with a peaceful, lump-free, money-saving
solution...
I went to the library instead of going to the movies
I triple-featured my way thru the travel books.
I already had itchy feet, but those pictures in the travel
books clinched it
That and this blues I once heard a blind man singing...

Dawn was breaking when I stole away
Left a note when I slipped away
Don't worry, your loving son...I'll be okay

...the first time I heard LOVE ME SOME HIGHWAY, it was as if somebody was reading my mind. You still had a lot of blind men coming up from "Down South" traveling around back then...you gotta eat...And...since they couldn't see the cotton to pick it...they went into the entertainment business.

There'd always be some blind man singing to beat the band, wandering down the street with some raggedy little boy holding his hand.

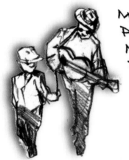

Momma told me not to leave,
Papa told me not to touch the door...
Momma told me not to leave,
Papa told me dont touch that door
They said why you wanta ramble boy...I said caint stay put no mo
Cause I just...Lo-ove me some high-yi-way...
I gotta go...I gotta go...I gotta go
I just Lo-ove me some high-yi-way
I gotta go...gotta go, I gotta go

My folks were fine...My mother was sweet, and my dad was kind

...Even back then I had enough sense to know that being a seeing-eye dog for some blind man wasn't going to be much of an existence. Yeah, but I was ready to change places with each and every raggedy boy leading a blind man that I saw...

I wanted to hit the road...see the world...

Whiskeyheads take their worries to the bottle,
Church folks take the lord their load
Whiskeyheads take their woes to the bottle,
Church folks take the lord their loads
I just wanta be over yonder hill, just further on up the road...
Cause I just...Lo-ove me some high-yi-way...
I gotta go...I gotta go...I gotta go

I'd never been down South, but the original version of the song sounded so down-homey, I could almost feel the mule pulling the plow.

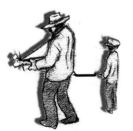

Lord knows, you been a true friend, mule
But I'm letting these here ole reins go
When I get to the end of this here field mule
I'm letting this here ole sharecropping go
I'm kicking this here ole cotton and hitting the road...

Well, one never knows do one? Every now and then an old black country tune would hit it big. The blind guy would keep the melody and kinda turn the lyrics citified and go get himself a new guitar and a jump combo...

Oh girl you as sweet as can be
You the prettiest thing ever walked on two feet
Sugar your loving just caint be beat
Woman you the most best thing on two feet
But there's a whole world out there waiting I just gotta see
Cause I just...Lo-ove me some high-yi-way...
I gotta go...I gotta go...I gotta go
I gotta go...gotta go, I gotta go

All I knew was I had this urge to get into the wind...
I couldn't get it out of my system back then.

I gotta go...I gotta go...I gotta go
just gotta go...gotta go...

I never said my prayers without asking Heaven for a helping hand
With talking my dad into letting me go off leading some blind man...

I'd never been warned...too young I guess...
To have heard that old expression about tears
You know, about being careful what you wish for
About more tears being shed over answered prayers than unanswered ones.

Anyhow, my father was doing a repair in one of the apartments, flat on his back
unplugging a drain, when the tenant's jealous husband comes home
and without even looking, figuring it's his old-lady's lover down
there trying to hide under the sink, pulls out his gun and
starts shooting...

POW!
POW!
POW!

The cops didn't even call it homicide.
The guy didn't even spend a night in jail...
The white police just chuckled about it.
 Just niggers fighting, they said...

Lord I'm not questioning your majestic wonders to perform
But since you gave me such a steep way to run
caint you fix it for my babies some

The landlord still couldn't rent the apartment so he let us stay up there for free but things were pretty tough...

I know you're only testing lord
But please stop testing just this one time

...The least I could do, I told myself, after all the harm my prayers had done...

Jesus seems you always go out to coffee-break
When a black prayer is next in line

...was lighten my mother's load...mouths to feedwise, is what I mean.

Just take your hands off that hambone Leroy
You just hold up there til I'm finished Boy
While I'm trying to fix it with the Savior for you

...Not to mention that it was what I had wanted to do in the first place.

Lord you know and I know that they sure were fooling
Drunk or something, when they named that game coon-can
'cause here's my soul to Heaven a black woman sure can't
Since they're holding all the aces give my babies a peek in their hand

I left a note, just like in the song, "I love you one and all. Don't worry. I'll be okay."

Just you stop fiddling near the biscuits Milton
Just you hold up there til I'm finished son
While I'm trying to fix it with the Savior for you

I was ready to roll...

Lord my days are numbered like the book say wont be here always
Oh lord please take care of my little crows lord
'Case you didn't know that's black for dove
You've got to help me lord all I got is this tired old mother's love

I was ready to skedaddle...I was ready to walk, run, whatever...

Devil gets all young'uns that don't listen
You just hold up there til I'm finished chillun...
In the name of the Father and the Son and the Holy Ghost

AMEN...

I even had myself a contingency plan
My Saturday matinee triple-feature-show-fare-money...
I had myself a stash of coins in a tin can,
I had saved every penny since way back when...

I snuck down the three flights of stairs...
Hit the sidewalk and sniffed the night air
heading for the tropics with which
I had fallen in love.

Middle of the night, outskirts of town,
I had gotten as far as Steubenville Ohio...

When out of nowhere this big guy, in this big truck,
With tufts of red hair coming out of his nose and ears, pulls up.
.
He leaned out of the cab and said, "Where you going, kid?"
"Kid!" I said. "How big do men get where you come from?"

HAUL
WITH
PAUL

SWEETBACK

"Sorry, no offense, son..." he said. "You just look so young.
How old are you anyway?"
"Seventeen"...I replied. I was fourteen, but I lied.
"Where you headed?" he said.
"Gulf of Mexico...the Yucatan," I replied
"Great, what a coincidence, me too...come on..."

So I hopped in.
Red said I looked beat and invited me to climb up on the bed behind the
front seat and get some shut-eye.
So I crawled up and fell asleep.

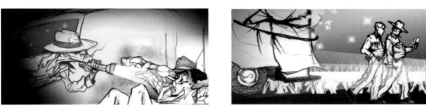

The next thing I knew there was this light shining in my face...it was the Police.

They said, "What's going on here?" Red said, "Nothing but the breeze."

They say, "You sure you're not carrying any contraband?"

Red comes back with, "Officers, look, if I was doing anything illegal, do you think I would have that kid up there asleep? I'd have some gorilla riding shotgun next to me on the front seat."

"Well, that makes sense," the cops say. "But we gotta check it out anyway." And they start towards the back of the truck.

Red yells'em back, "Hey...er...wait a minute, fellows. Look, I'm in a rush," he says and slips each officer a few bucks.

"Well, uh," they apologize for troubling him, "we see what you mean," and let us go. We pull off. I ask Red what that was all about back there.

He didn't really know, he said, but he's heard there was some kinda gang war going on, some bad guys who were bootlegging cigarettes or something, arguing over territory.

We come around this bend and start up this hill. We're tearing along this high narrow road, with a cliff on one side and trees on the other.

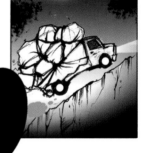

"Smell the water?" Red said.

I said, "Yeah..."

"Well, we're almost there."

"Almost there?!!" I said. "I thought it took two days to get down to the Gulf of Mexico."

"Well, you were pretty tired," Red says.

Just then...

The two right tires blew. The truck started swerving. To tell the truth, I didn't expect to get much older, but we managed to make it to the shoulder. Down over the cliff, far, far below I could hear the rocks arguing with the surf. Anyway, Red had just changed tire number one. I was holding the flashlight and standing there with inner tube number two all pumped and primed and ready to go.

Red bends down again...Just then three men emerge from the forest, carrying guns and wearing those mobster hats with the big brims.

"WOW," Red says, "those are some of Fatty Kalawalski's guys. I'll handle it. Don't tell'em NOTHIN!"

Don't tell'em nothing?...I didn't know NOTHIN!

Red straightens up and steps forward, trying to grin. "Look, fellas," he starts blubbering, "...I can expla..."

Each mobster pumps a slug into him. Red was as thick as an oak tree, but the bullets were so big they went clean thru him. I mean they went in and back out again. One got him in the stomach, one got him in the heart and one got him in the head.

Red fell over dead.

Of course, that left this big-ass question hanging in the air...

Big Brim Number-One says, "What are we gonna do with the kid? I figure he don't know nothing. I suppose we just oughta let him go."

Big Brim Number-Two, meantime pointing his gun at me, says, "Why take a chance..."

I didn't wait for Big Brim Number-Three to vote. I jumped off the cliff.

It was all foggy down below...and, naw, I didn't know what was DOWN THERE! But I knew what was UP THERE!

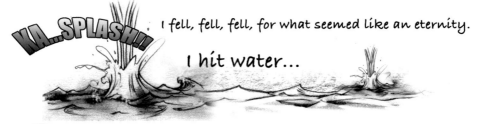

I fell, fell, fell, for what seemed like an eternity.

I hit water...

I'm flailing around as best I could...Back then I couldn't swim too good. Something gigantic brushes me...It was out there circling me...sizing me up to be lunch meat...

I had the ends of the earth to go see...CRAP ON THAT!...
I was doing battle with the creature
I was punching away with one hand
I was using the other one to hold the contingency can
We were thrashing and bobbing and stuff
I get my legs around him...I'm about ready...to take a bite out of his butt
 ...When I REALIZE **WHAT THE F?** ...I didn't curse back then
It wasn't a shark or some kinda Loch Ness Monster
It was the inner tube from RED'S TRUCK
The Lovely...Wonderful...Glorious inner tube
So I climb in....I float all night. Toward dawn I see this faint fiber of lights...
This long thin clothesline of pearls
I'm figuring I must be in Havana or the Yucatan...
Way off I see someone signaling me, not moving or anything
A lady holding up this lantern in her hand

A'que pasa...Ándale...Caliente...Amigo...Arriba...Buenos Días...

By her size I realize she couldn't be more than a block away
But what musta been a coupla blocks later
she didn't seem much closer, only bigger
And she hadn't moved a muscle either
Not only that, she had started looking familiar too,
but there wasn't anybody in the Yucatan that I knew.

A mile later, same story. She just kept getting bigger and bigger. Plus that overhead some kinda skinny cloud, with this weird rumbling-grumbling going on up on top, floats by blotting out the stars...I'm figuring I must be delirious.

Yeah that was it...Naw, that takes a week. I knew I hadn't been paddling that long!...Finally I recognize the lady with the upraised arm. It was every immigrant's MOM, it was Miss Liberty HERSELF!...

That fibbing Red had lied to me. He hadn't taken me down to no Beaumont, Texas, or to no Key Largo. I shoulda suspected something sooner by how filthy the water was. Red had driven us East, not South. I wasn't in the Gulf of Mexico...I was floating down the Hudson...The fog started to lift...What did I see, Emerald City...N.Y.C.!!!...and I'd almost drifted past it.

I managed to make it to shore down at the bottom of Manhattan, half dump site and half rotting piers back then.

You know what I can't stop wishing?...
That I had one of those science fiction time machines...
So I could beam me back to back then and lend a helping hand...yeah
...but, I guess that's what living is all about in the first place, learning to deal with what life shoves in your face, "bought knowledge be the best knowledge," they say...
The minute my toe touched Manhattan granite I was reborn...dawn was coming, that was a good omen, pink had started scratching the sky...

But back to what I was saying, that teaching-the-ropes thing. I still wish that I coulda hung out with the me back then and run it down to him.

First you peep the pieces, then you figure out how to make 'em fit...
The Big Apple ain't all that malevolent...YEAH...but it can be a BITCH.

Okay I was farther North than intended, but my game-plan was still the same. Since there were no driveways leading up, or highways heading to, the ends of the earth where I wanted to go, I was gonna join the merchant marines and let the oceans be my road. I looked up the address in the telephone book and started hoofing.
I figured I'd walk..."Waste not want not," save my money. But the Union Hall turned out to be a little farther than I thought. So I figured I'd play hobo too...spend the night on some park bench and save on rent.

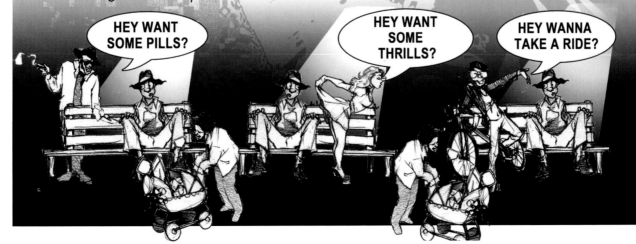

Finally...morning came, dawn just like in that song "The Apple Stretching"

...The sun comes swaggering across the harbor
And kisses the lady waiting in the narrows
She already plenty shaky stands there
Blushing, clutching the torch of liberty...
No, it aint Judgement Day...No, it aint Armageddon
It's just the Apple stretching and yawning,
Just morning. New York putting its feet on the floor

On the way to the Union Hall I splurged and bought a tie, figuring to make myself look older. It didn't work...they insisted on seeing my certificate of birth. I had three years, two months, six days to go before I was an official adult. I was stuck. Yeah, STUCK IN PARADISE, things couldn't have been much better...

There I was, ME, in three-D, in living color, smack-dab in the center of everything, except of course the travel, I'd dreamed of sitting back there in the library, Times Square, Central Park, and of course Harlem...
 One night on the street had cured me of my hobo fantasy, so I looked around for a place to stay...
 The landlady at the rooming house gave me the third degree

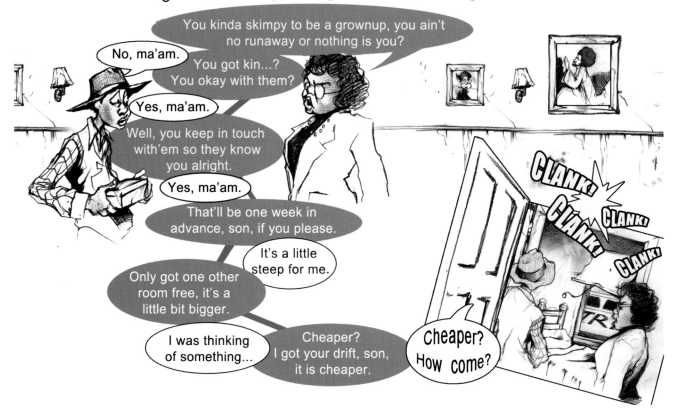

You kinda skimpy to be a grownup, you ain't no runaway or nothing is you?

No, ma'am.

You got kin...? You okay with them?

Yes, ma'am.

Well, you keep in touch with'em so they know you alright.

Yes, ma'am.

That'll be one week in advance, son, if you please.

It's a little steep for me.

Only got one other room free, it's a little bit bigger.

I was thinking of something...

Cheaper? I got your drift, son, it is cheaper.

CLANK! CLANK! CLANK! CLANK!

cheaper? How come?

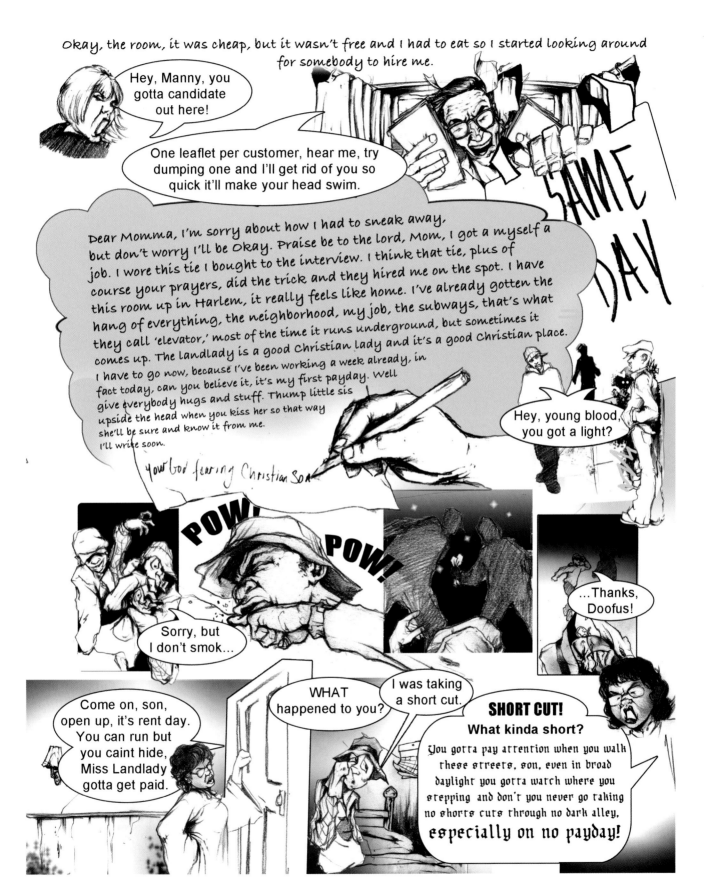

Okay, the room, it was cheap, but it wasn't free and I had to eat so I started looking around for somebody to hire me.

Hey, Manny, you gotta candidate out here!

One leaflet per customer, hear me, try dumping one and I'll get rid of you so quick it'll make your head swim.

Dear Momma, I'm sorry about how I had to sneak away, but don't worry I'll be Okay. Praise be to the lord, Mom, I got a myself a job. I wore this tie I bought to the interview. I think that tie, plus of course your prayers, did the trick and they hired me on the spot. I have this room up in Harlem, it really feels like home. I've already gotten the hang of everything, the neighborhood, my job, the subways, that's what they call 'elevator,' most of the time it runs underground, but sometimes it comes up. The landlady is a good Christian lady and it's a good Christian place. I have to go now, because I've been working a week already, in fact today, can you believe it, it's my first payday. Well give everybody hugs and stuff. Thump little sis upside the head when you kiss her so that way she'll be sure and know it from me. I'll write soon.

Your God fearing Christian Son

Hey, young blood, you got a light?

POW! POW!

Sorry, but I don't smok...

...Thanks, Doofus!

Come on, son, open up, it's rent day. You can run but you caint hide, Miss Landlady gotta get paid.

WHAT happened to you?

I was taking a short cut.

SHORT CUT!
What kinda short?

You gotta pay attention when you walk these streets, son, even in broad daylight you gotta watch where you stepping and don't you never go taking no shorts cuts through no dark alley, **especially on no payday!**

Humph, well, you gave me a week in advance so I guess I can give you a little slack this one time. Well, you don't need no lecture OUTTA ME, you go on to sleep, boy, looks like you learned your lesson.

I guess nobody won't ever be having to be telling you to be careful again, will they? Well, like the ole folks say, "Bought knowledge be the best knowledge," and you sure done paid your tuition, ain't you?

Yes, ma'am.

Despite the title, being a "Sandwich-Man" didn't offer much in the way of nutrition. Keeping up with the rent didn't leave much for food. I had a roof over my head, but that was about it...I told myself I wasn't hungry, but you can only bullshit your body so long... I was going down this street, and suddenly my hand, on its own accord, comes shooting out of my sleeve... Another pair of hands grabbed after the same apple as me... Just then a cop shows up.

The kid I'd been struggling with points behind the cop's back.

Oh my God, LOOK!

The cop falls for it, and we haul ass... that's how I met Jones...

What the hell you boys think you're doing?

Where's your apple?

That's it, you took it.

So why didn't you grab another one...that's the fun of it?

I didn't do it for the fun.

Ooh, okay, I get it...afraid of spoiling your dinner and catching it from your mom when you get home, hunh?...

I don't have a home ...I was just hungry.

After a couple of blocks the cop gives up chase, we turn a corner, and my partner in crime offers me the apple.

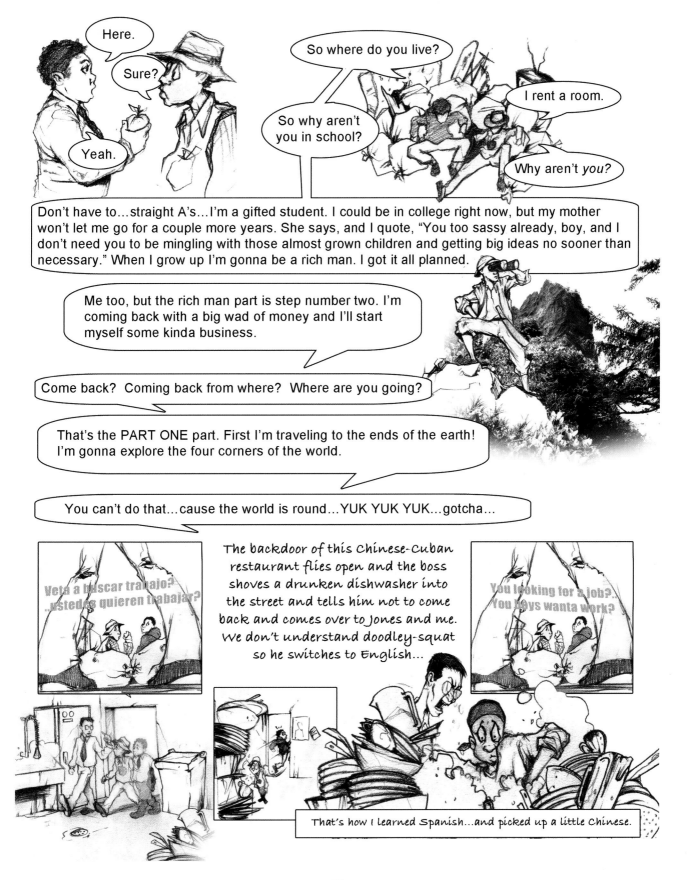

Here.

Sure?

Yeah.

So where do you live?

I rent a room.

So why aren't you in school?

Why aren't *you?*

Don't have to…straight A's…I'm a gifted student. I could be in college right now, but my mother won't let me go for a couple more years. She says, and I quote, "You too sassy already, boy, and I don't need you to be mingling with those almost grown children and getting big ideas no sooner than necessary." When I grow up I'm gonna be a rich man. I got it all planned.

Me too, but the rich man part is step number two. I'm coming back with a big wad of money and I'll start myself some kinda business.

Come back? Coming back from where? Where are you going?

That's the PART ONE part. First I'm traveling to the ends of the earth! I'm gonna explore the four corners of the world.

You can't do that…cause the world is round…YUK YUK YUK…gotcha…

Veta a buscar trabajo? …ustedes quieren trabajar?

The backdoor of this Chinese-Cuban restaurant flies open and the boss shoves a drunken dishwasher into the street and tells him not to come back and comes over to Jones and me. We don't understand doodley-squat so he switches to English…

You looking for a job?.. You boys wanta work?

That's how I learned Spanish…and picked up a little Chinese.

The job didn't turn me into no John D. Rockefeller...
Cash in hand it wasn't much more than being a sandwich-man.
However I did manage to catch up on my rent and replenish my contingency can.
But most of all I was getting my food for free!.. arroz blanco, arroz amarillo,
frijoles...and sometimes half a steak somebody didn't finish.
Big picture-wise I'm figuring, with food and shelter accounted for,
I had all my priorities covered.
Then...speaking of priorities...

I'm approaching maturity see – ANOTHER PRIORITY...

In fact...it had been creeping up on me
for quite some time, comes shoving and pushing into
the picture. I didn't know any young folk but Jones
so I looked him up. He introduced me around and
taught me the courtship ropes...

...He had to start from scratch though.

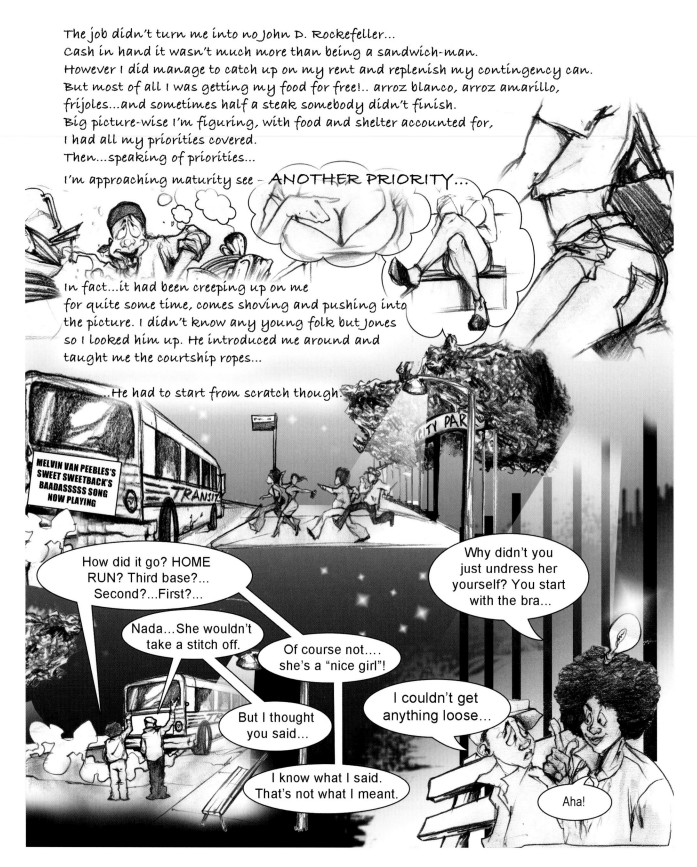

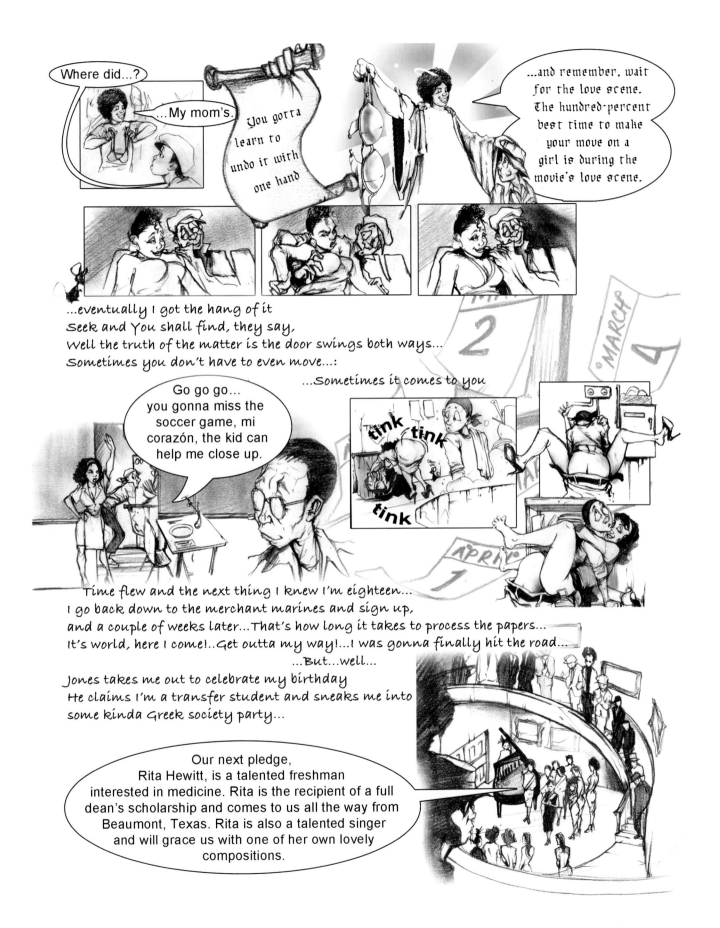

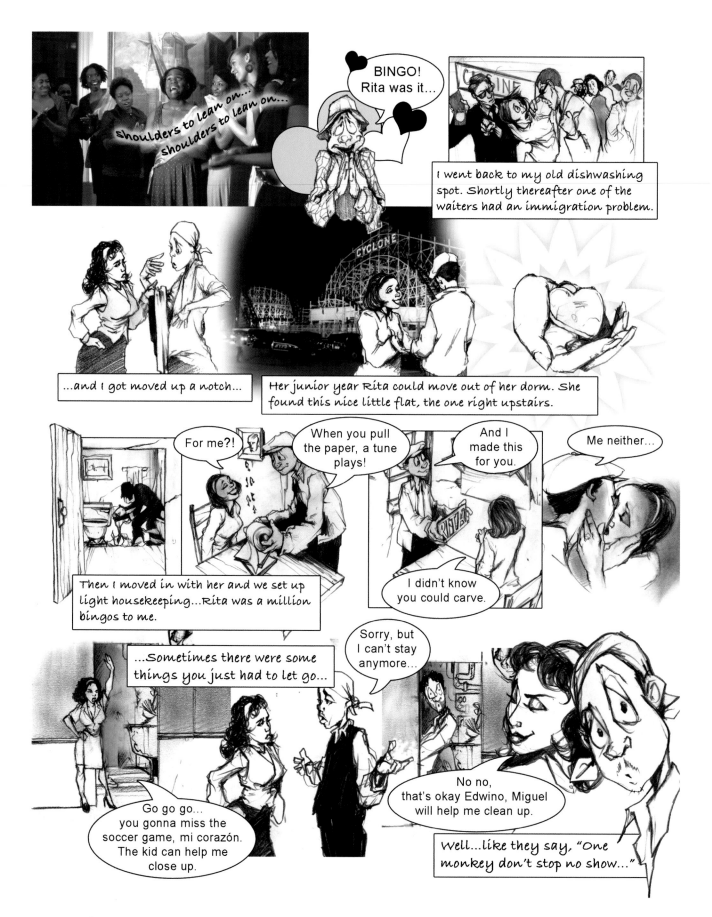

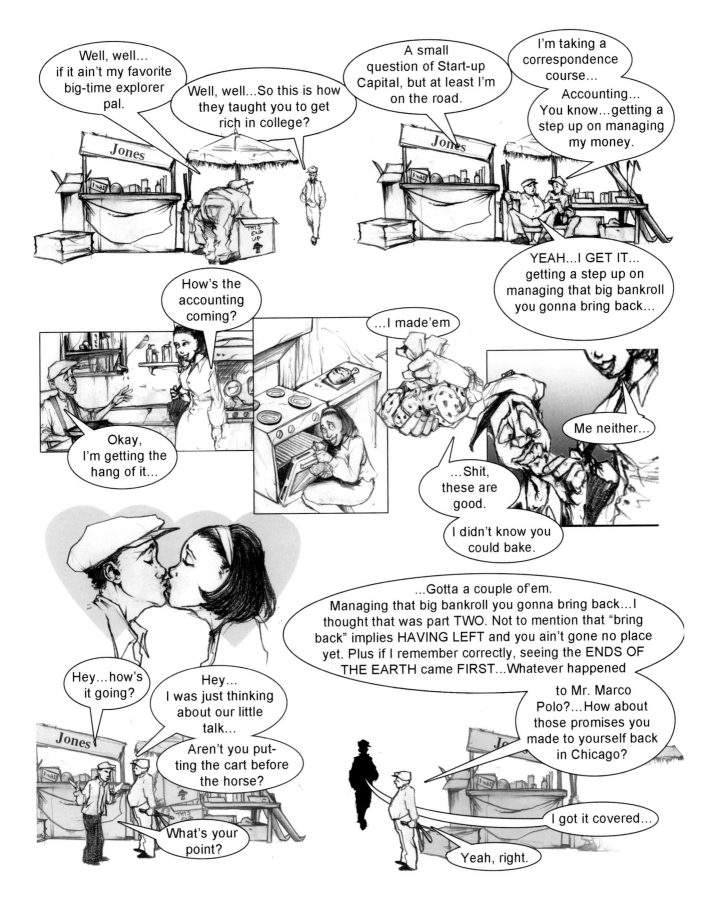

21

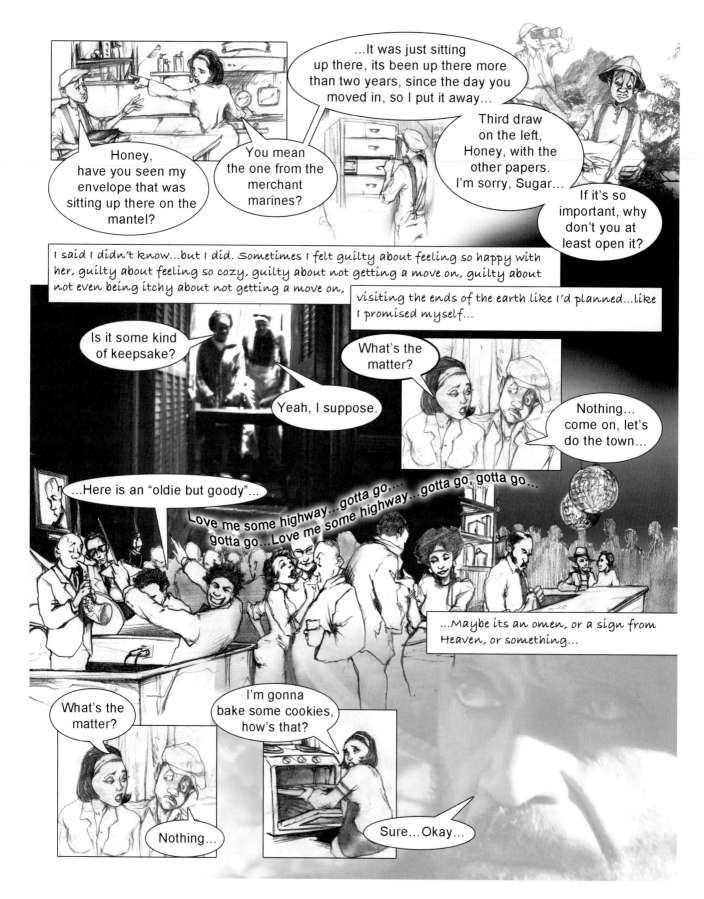

The cookies were good and so was the funky monkey,
but I woke up in middle of the night with that old blind
man and his guitar calling me.

We, Rita and me, had started a nest egg together for our future.
We had three hundred and sixty dollars in it already. We'd always put in money 50/50 evenly,
straight down the middle. So I was in for one hundred and eighty, but I only took out fifty

...That was that...I folded the
fifty, put it on top of
my contingency stash
and buried the cash.

Anyhow...I was finally hitting the road and my conscience was more than acquitted.

Why did I even bother taking the fifty? Well like they say, "Hindsight is 20/20."

But I was too doofus to understand the "why" back then...

Anyway it was, "Hey world here I come..."

I zigzagged the equator a thousand times...like I vowed I would.
I touched every continent, sailed all seven seas, probably not a harbor
...natural, man-made, frozen or baked I didn't see
...while I was at it I opened every bar
and every pair of knees from here
to Singapore...and then some...

But...to tell the truth...that explorer's high,
that happiness, that bliss they claim you feel
when you reach the ends of the earth,
well...it kept eluding me...

I was at sea for eleven years,
the first five, musical chairs, ship to ship, filling in as "the temp." Then the "Christina"
lost a man and I was assigned to her. When the captain saw I knew my way around a
deck and that me and the rest of the crew were hitting it off, he made me a "permanent"
and I spent the next six years on her.

"Christina" was privately owned and operated, but we got a share of the big jobs
anyway, mostly to ports in "iffy" waters. Waters that the large companies considered too
dangerous.

The captain wasn't some kinda daredevil, but he wasn't a scaredy-cat either. He and
the first mate had been Seals in the navy. If there was a reasonable profit to be made and
not an unreasonable risk to be taken, the "Christina" was in. Sometimes, of course, there'd
be trouble...On land you can usually smell when you're in a rough neighborhood, but on
the ocean you can't. Anyhow, we got to visit some wonderful places...

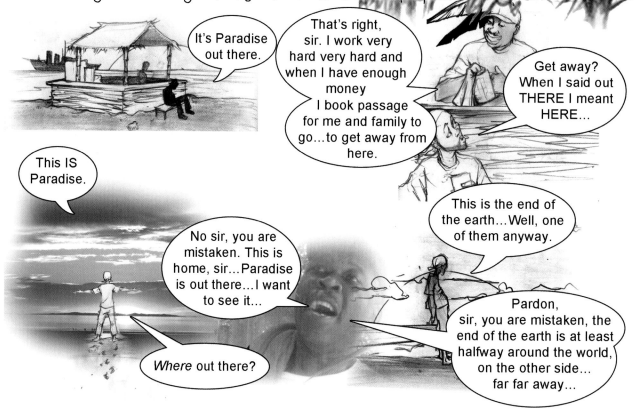

24

...That halfway around the world remark stuck in my craw. The four corners of the earth weren't doing it for me...It wasn't that I was unhappy, it was that I had been happier...
But where...when?...Well there was this craving to see New York again tugging at me.

On the other hand, unfortunately, I hadn't gotten around to the second part of my life plan...the becoming a rich man part. Carousing can be pretty expensive. I stayed pretty broke, just like the rest of the crew, everybody that is except my roommate Fernando.

Fernando barely touched his salary. Word was he had three or four years' pay stashed in the captain's safe. Aboard ship, out at sea, he pulled his weight as good as anyone, but ashore it was a whole other thing. He'd never hang out with the rest of us, he just disappeared...the rumor was that he was gay.

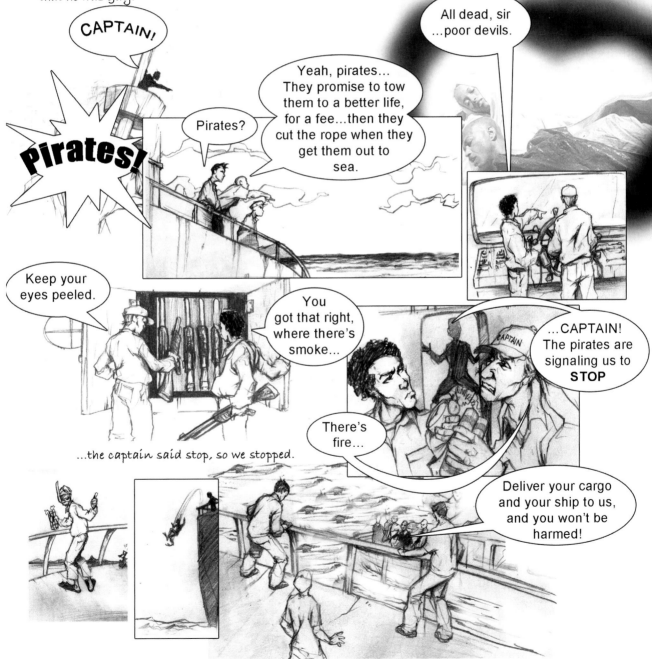

...the captain said stop, so we stopped.

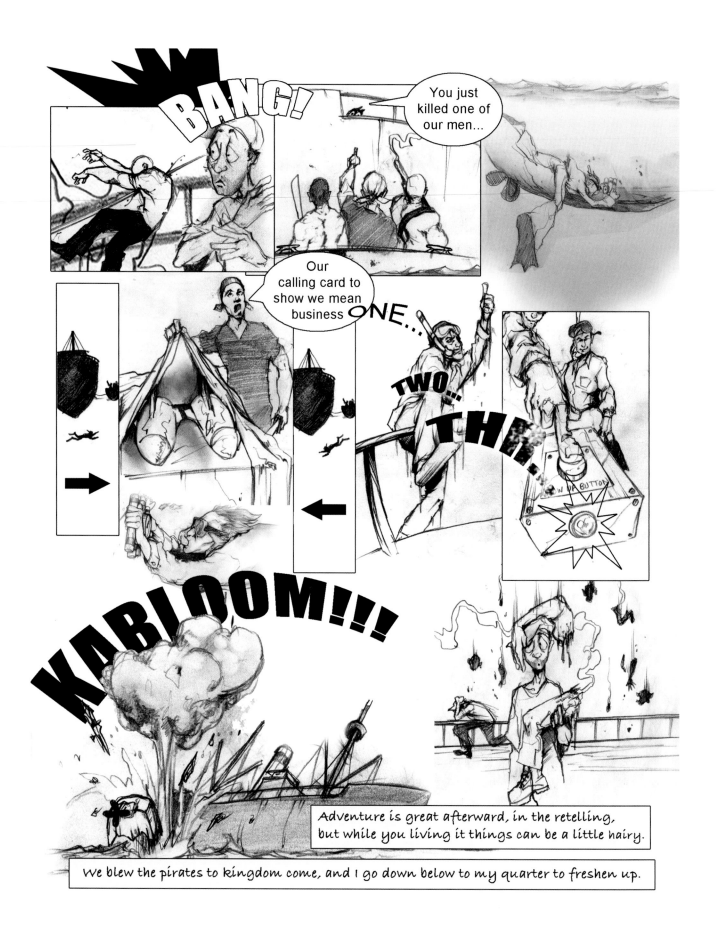

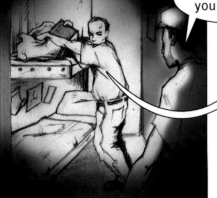

What the hell you doing?

I'm packing up your stuff for you.

How come?

Fernando replied that he figured now that Karl was dead I'd be moving in with Scotty, now that I wasn't gonna be the low man on the totem pole, the new guy any longer. "So what?" I said, not getting where he was headed.

"So you won't have to share a room with me anymore," he said.

"I don't have to move, do I?"

"I guess not," he replied and shrugged. "But, you know...staying...when you don't have to, might give people the wrong impression."

I told him there was no impression to give.

Fernando shoots me this look, "Well, birds of a feather they say," and pauses then spits it out: "You think I'm gay?"

"What the hell?" I answered. "Every time we hit shore...POOF!...You just disappear..."

"I don't disappear. You guys just never leave the joints on the waterfront."

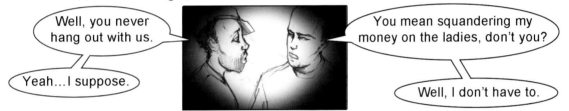

Well, you never hang out with us.

Yeah...I suppose.

You mean squandering my money on the ladies, don't you?

Well, I don't have to.

"Well...good for you, my friend," I said. And started unpacking my stuff and putting it back where it belonged. I was straightening out my blankets and he was standing in a corner watching, trying to make up his mind about something....

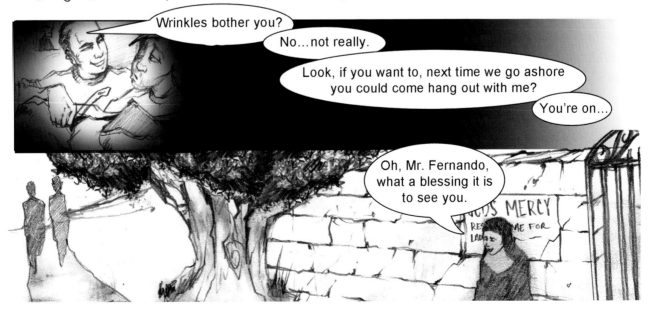

Wrinkles bother you?

No...not really.

Look, if you want to, next time we go ashore you could come hang out with me?

You're on...

Oh, Mr. Fernando, what a blessing it is to see you.

GOD'S MERCY
RESCUE ... ME FOR
LADI...

The nun said she supposed Fernando had been around the world again since the last they had seen him and then turns to me and starts gushing to me about what a saintly man he was, "...So wonderfully compassionate, so full of empathy for the elderly..." Fernando gives her this sedate smile and says it's his pleasure and the nun beckons us to follow her.

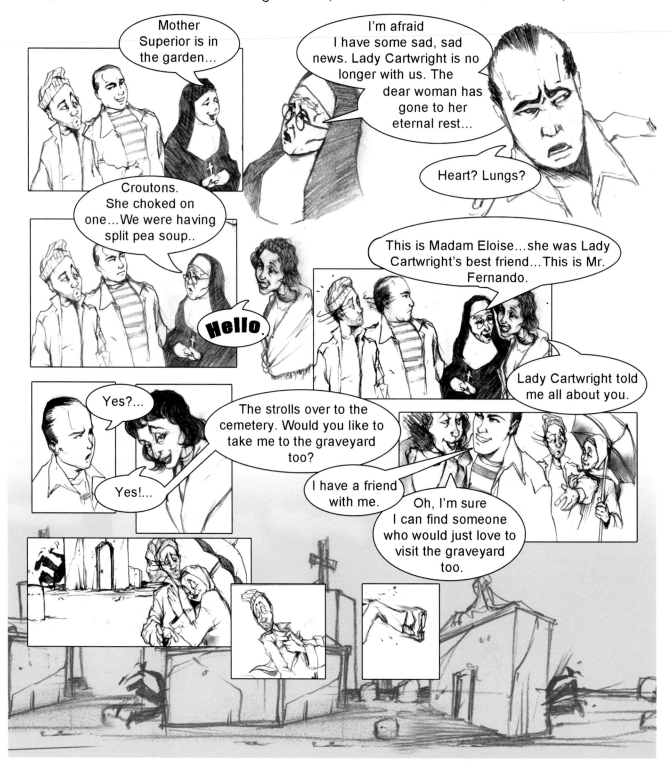

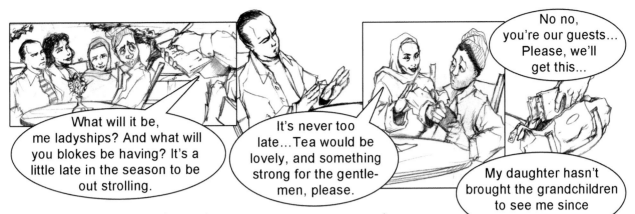

What will it be, me ladyships? And what will you blokes be having? It's a little late in the season to be out strolling.

It's never too late...Tea would be lovely, and something strong for the gentlemen, please.

No no, you're our guests... Please, we'll get this...

My daughter hasn't brought the grandchildren to see me since Easter.

Well I started 'disappearing' with Fernando whenever we hit a port.

The ladies always insisted on paying for everything...the rooms, the refreshments...Lots of times, overwhelmed with gratitude, they'd even try to sweeten the pot with hard cash. We'd always refuse, they got a name for guys like that.

I think breaking the monotony—who wants to crochet all day—had almost as much to do with their gratitude as the hanky-panky. On the other hand, to tell the truth, "Snow on the roof don't mean there aint a fire in the furnance."

Anyhow, a few ports later, this registered letter from one of Fernando's elderly lady friends caught up with him. She'd passed away and left him a little chateau in her will and Fernando withdrew from the sea for the life of a country gentleman. Speaking of the truth, red-hot mommas are just like athletes, they don't like retiring. The reality of the matter is, which side of the hill a woman is on and such doesn't really count for much. In fact, as quiet as it's kept, most old ladies aint so saintly.

Take Madame DuBois, she was one of the names in Fernando's book. Madame was a real talker, but her accent was so thick it took awhile to make out what she was saying. When I first laid eyes on her, because she was confined to a wheelchair, I thought I'd made a slip. Years ago she'd taken a fall, not figuratively, literally, and broke both hips. But, like I was saying, her motto was, "Where there's a Will, there's a way."

Less than four years later, "He helps those who help themselves," and Fernando had been a good teacher..."Monkey see, monkey remember what to do"...I managed to have a nice wad of cash stashed away in the Captain's safe.

Meantime for some reason this itching for New York was still growing on me. Meantime too the captain was trying to talk me into staying, saying to hold my horses and we were sure to be in North American territory somewhere within the next six months, "spitting distance, dump you at your doorstep..."

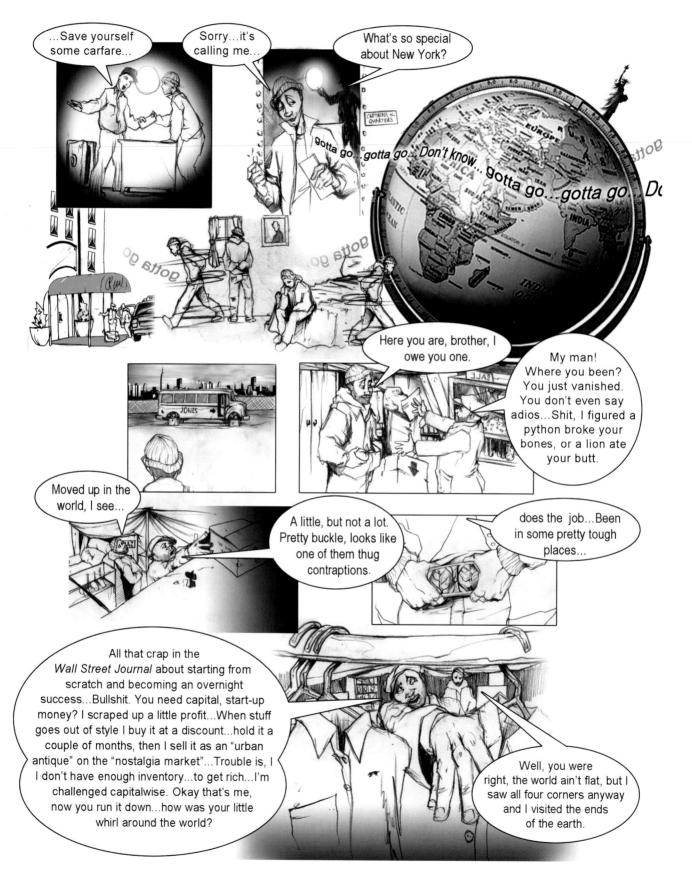

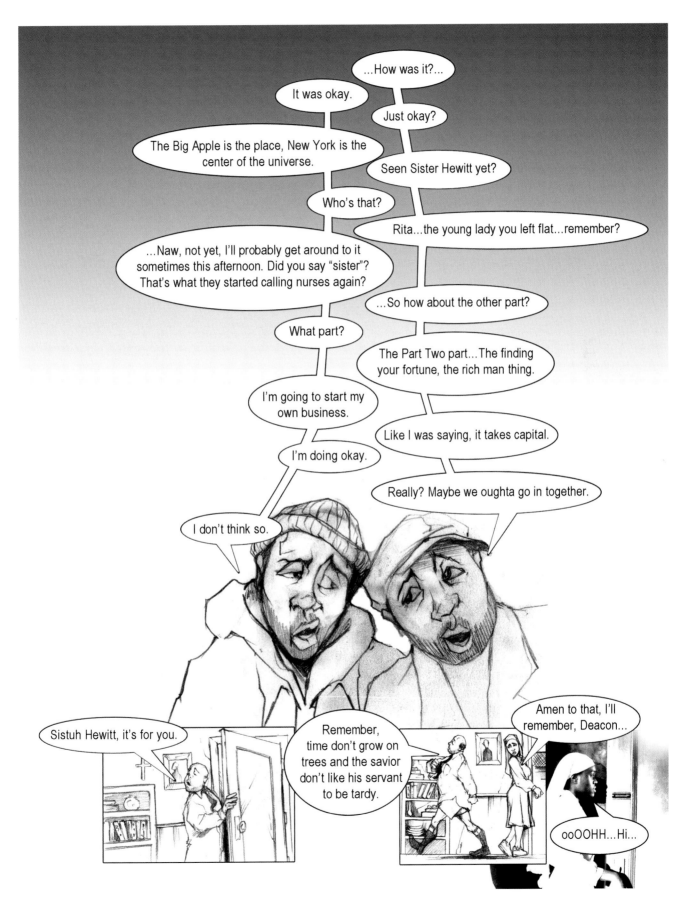

Oh! It's you

Of course it's me

You're alive...is what I mean. Seven years.

Eleven, Dear.

Seven. I stopped counting and caring after that.

I wrote.

That note...that postcard it took you four years to send.

I sent more since.

Too little, too late.

I know that's not a lot for eleven years...

Seven.

I was hoping we could resurrect us.

Resurrect us? I'm not Jesus and you're not Lazarus.

Cut me some slack. I wanted to make my fortune before I came back.

Money is the root of all evil. The Bible...

I did it...Don't go getting all righteous on me...Got something better than some shoulder to lean on.

Nothing is better than a shoulder to lean on.

Sister Hewitt, we got a flock to attend to.

Come on...I did it, I did it...Look at this wad.

Take thou wad of cash and shove it up thine ass.

Coming, Deacon.

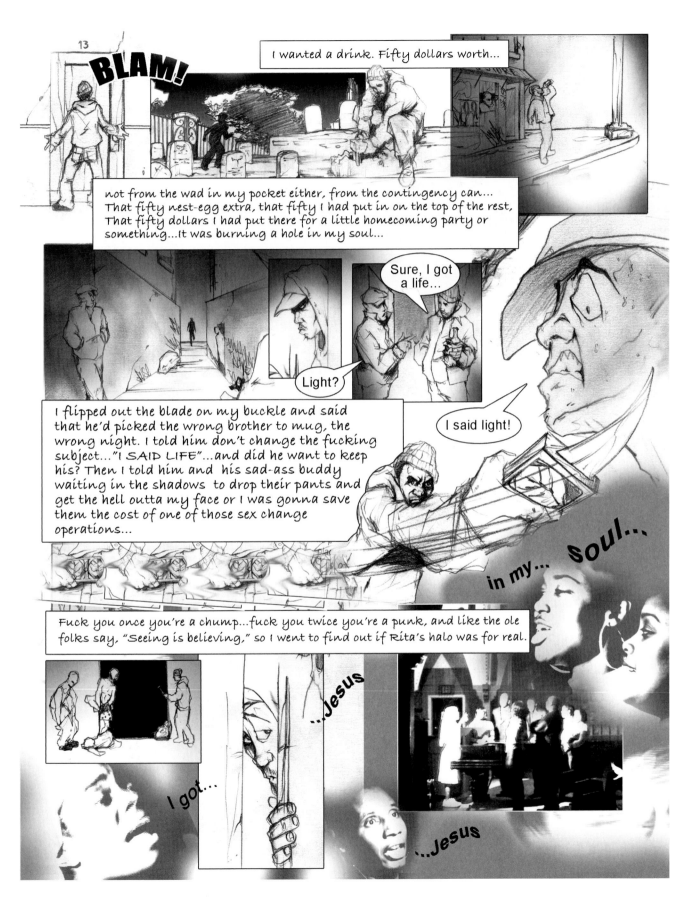

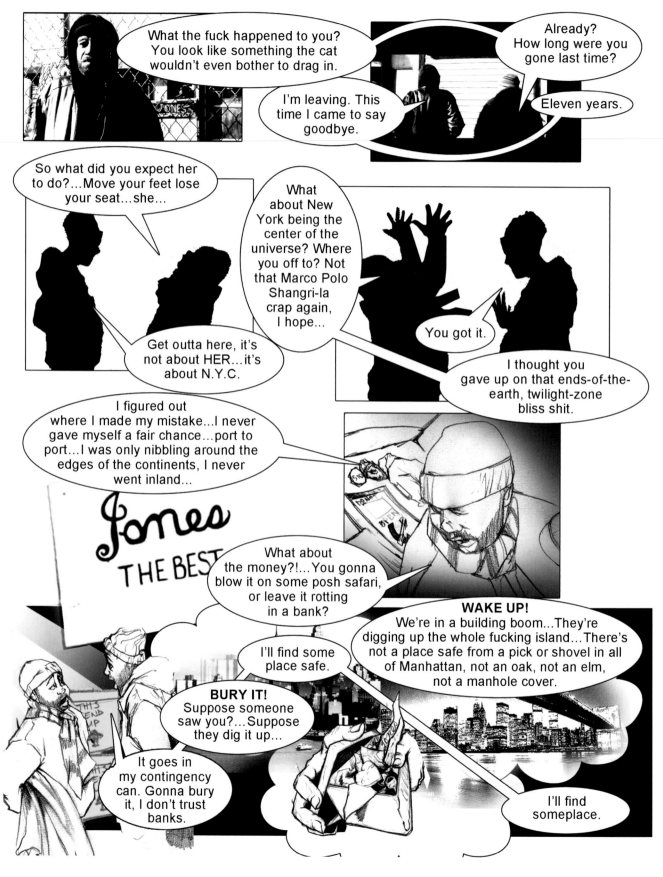

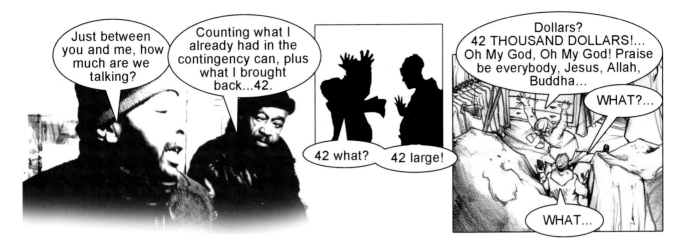

He said he couldn't believe it! He said, and I quote, "That's exactly the sum I...I mean WE. That's EXACTLY the sum WE need to launch the business big time. You GIVE ME the 42...INVEST in the business is what I mean, and we'll be partners, you won't have to lift a finger, I'll do the work and we'll split the profits 50/50...It must be a sign from heaven, that's exactly the amount I need...stock inventory and stuff...Not a penny more not a penny less. Well what do you say?"

I told him that'd I'd say he was S.O.L., shit out of luck, that I didn't have no 42. His mouth hit the floor on that one. He said, "I thought you said..."

I said, "I did say that, but that was everything. Out of that I gotta pay for plane tickets there and back...Suppose the first place doesn't do it for me and I want to try another continent or something...Plus I gotta eat, sleep."

Then he asked me...how much it would take...

I'd done my homework, so I told him, "Three thousand at least."

"No problemo!" he said and swore to me. "That's exactly how much I got in the business plan for opening new territories...You can be our traveling advance man. We can write it off as a business expense. That way you can do your ends of the earth searching for free...You'll be going on the company's dime..."

"What company?"

"Jones and...I hope you don't mind if I put my name first...since I started it."

'I was born at night, but not last night,' like the ole folks, so I started backing away, but he kept right on coming.

"We'll call it, Jones and Jefferson Unlimited," he said. "That'll be us!"

"Unlimited WHAT?" I said. "WHAT are we selling?"

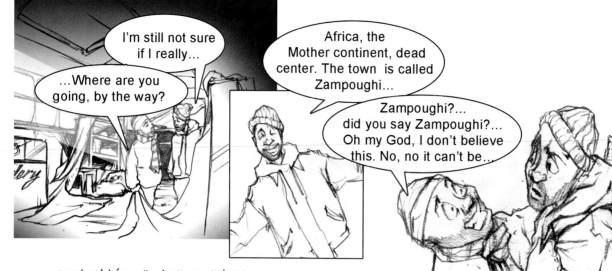

I asked him, "What can't be?"

He says, "Zampoughi! You did say Zampoughi, didn't you? No no, it can't be. That's exactly the place I had picked out for our first branch office."

I told him he was Bullshitting.

"No honest...I been in touch with the guy out there and everything..."

"What's his name then?"

Jones starts stuttering, "I...I...I don't have his name on the tip of my tongue...but I remember the town has a square!"

"They all do."

"Really?...Yeah, yeah...Uh, anyhow...like I was saying, his shop is right on the corner, great location. C'mon, brother, opportunity is knocking."

I wasn't so sure his intentions were pure, but then he lays that ole folks saying on me about, "You snooze you lose."

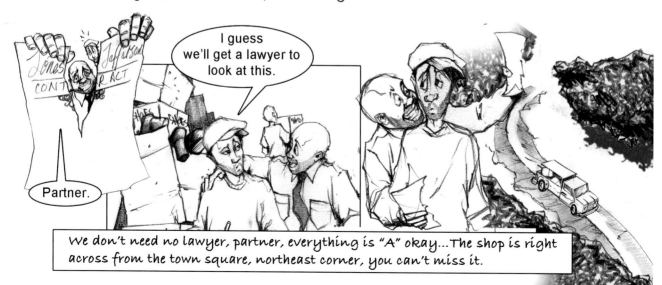

We don't need no lawyer, partner, everything is "A" okay...The shop is right across from the town square, northeast corner, you can't miss it.

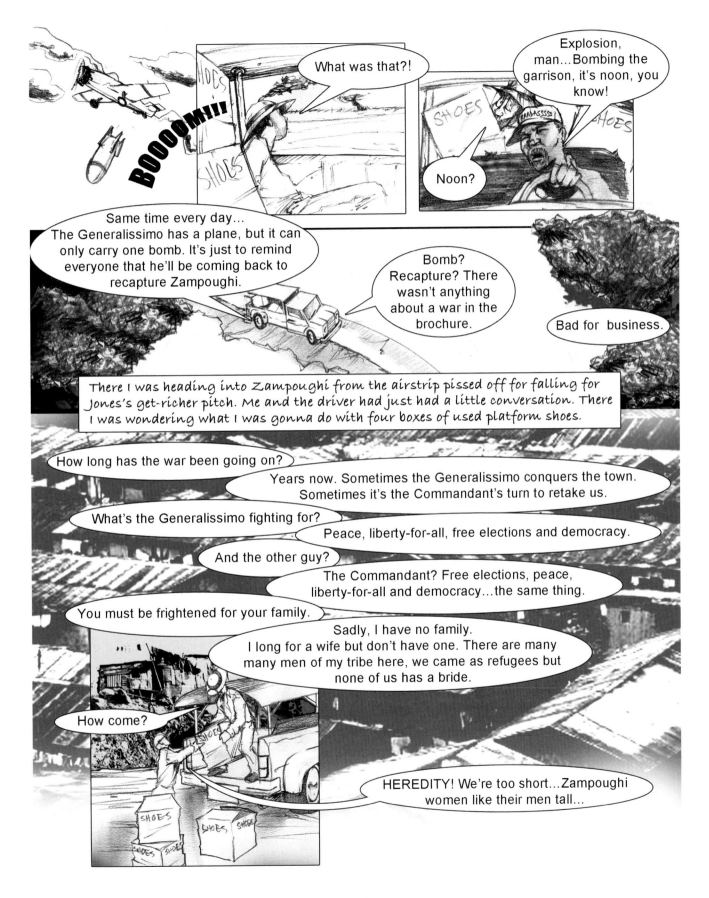

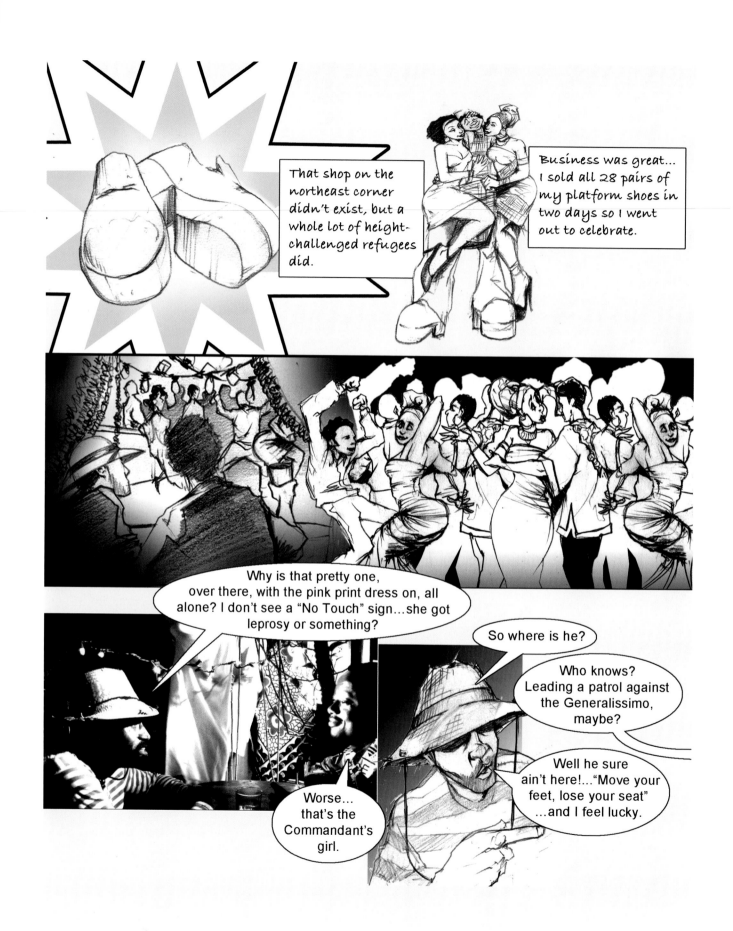

...My pilgrimage to Paradise was turning into one of those renaissance paintings. The big cautionary-tale ones, warning about the ravages of war, full of graphic depictions of medieval mankind showing its ass...

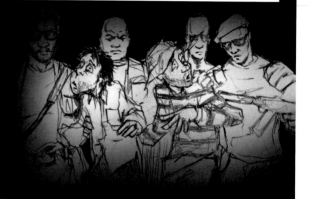

...The same mayhem, modern versions anyhow. The troops were the ones with the guns, but they started getting jumpy as the sun went down.

What's up with them? Scared of getting wet?

No, darkness. Soon it will be black. At night both sides shoot at anything that moves.

The village is abandoned, sir!

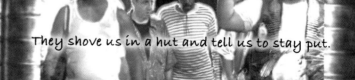

They shove us in a hut and tell us to stay put.

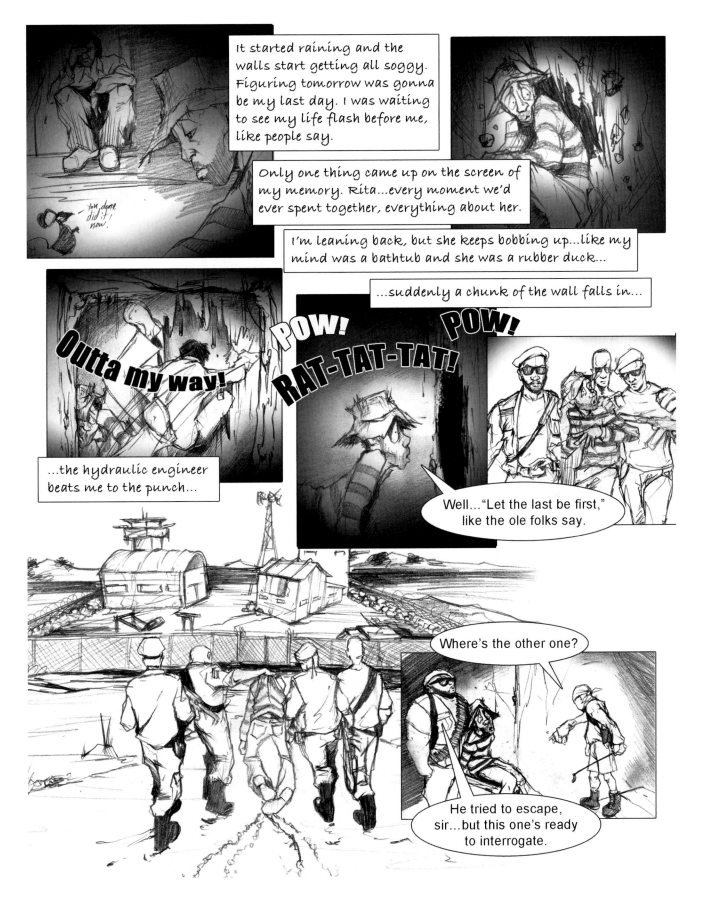

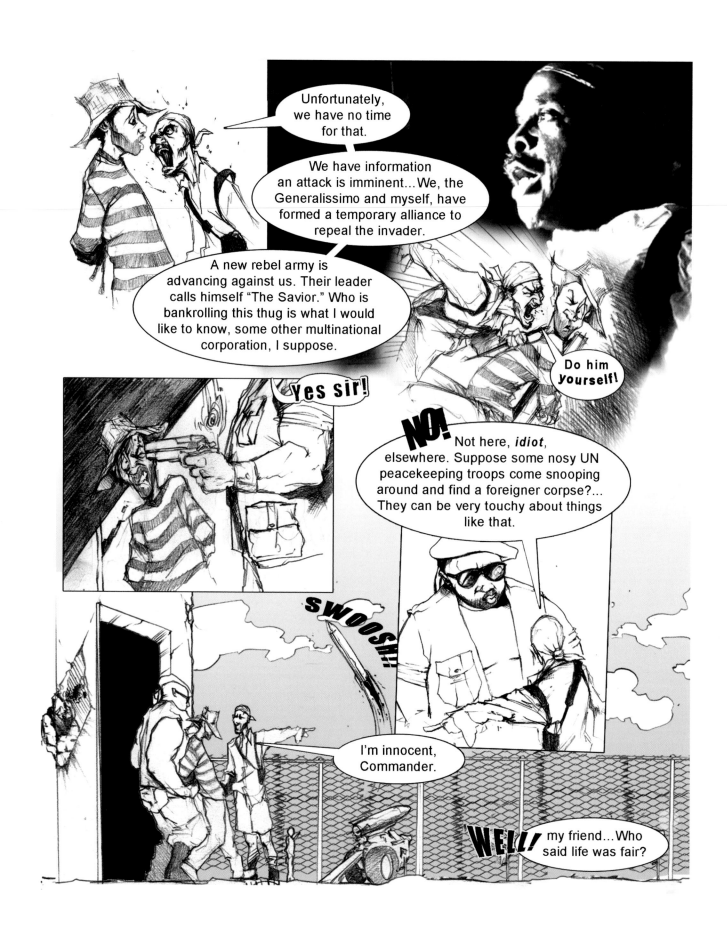

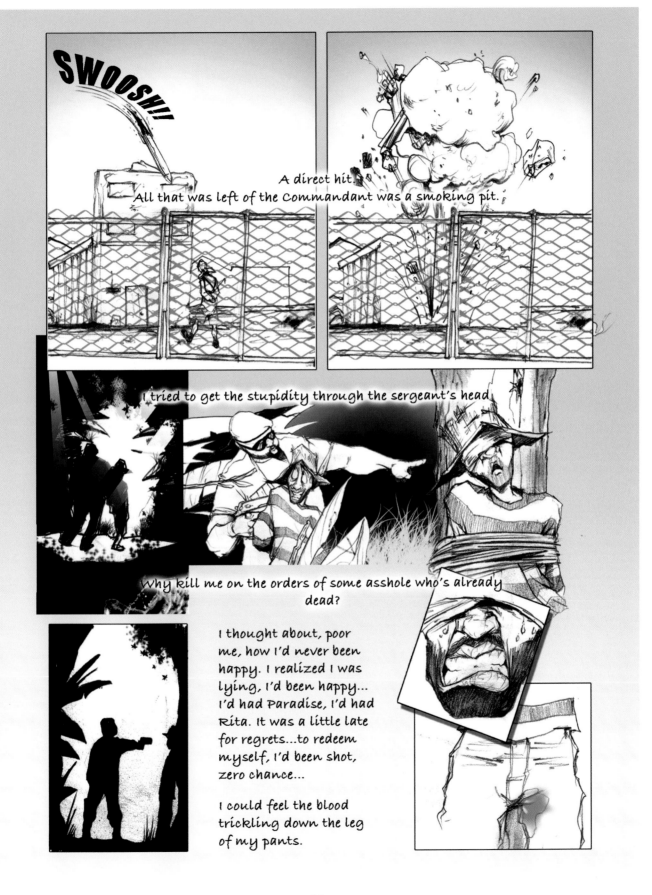

SWOOSH!!

A direct hit.
All that was left of the Commandant was a smoking pit.

I tried to get the stupidity through the sergeant's head

Why kill me on the orders of some asshole who's already dead?

I thought about, poor me, how I'd never been happy. I realized I was lying, I'd been happy... I'd had Paradise, I'd had Rita. It was a little late for regrets...to redeem myself, I'd been shot, zero chance...

I could feel the blood trickling down the leg of my pants.

Took a little wee-wee, did "WE"?

I told the Sarge "WE" never pretended to be Cpt. Courageous anyhow. He cuts me down.

FREE AT LAST FREE AT LAST... RITA, RITA...I'm coming to see'ya

BULLSHIT!!

It was out of the frying pan and into the fire for me. Sergeant had flipped from executioner to entrepreneur and sold me into slavery.

Turns out "The Savior," with all his slaughtering and war crimes, was running short on personnel, slaves-slash-infidels to work the mineral mines.

That's where the big bread was buried, down the mineral mines. In fact...DUH...control of the mines was what the fighting was really about all the time.

I'm in a file of slaves being loaded onto a truck heading for the mines...
 A gang of child soldiers is blasting a hip-hop version of my old theme song from a looted boom box.
 ME...I tried to go transcendental...to rise above my shitty inconsequential terrestrial situation.

To become one with the universe...
To transport my inner-self to a more positive space...
to concentrate...like I'm in a bar back home,
working out to the music, burning up the place...

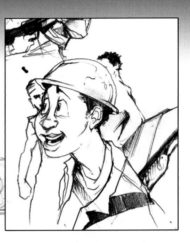

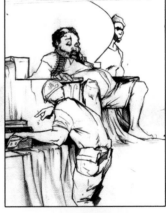

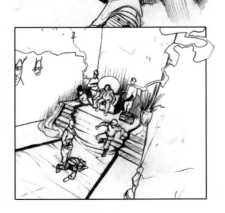

At first I didn't
know what they
wanted me to do.

Finally I figured
it out. They
wanted to check
my moves!

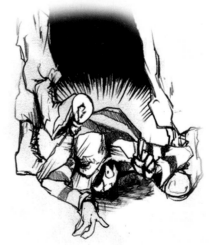

some highway... love me some highway... love me some highway....

The Bossman, "The Savior" they called him, shut off the tape. They figured he didn't like the show and started to drag me away.

STOP!

I like it.

...I was added to the ENTOURAGE.

The Savior liked his luxury so we traveled with him. We lived large in comparison with most of the population...

So the first time I tried to escape they weren't expecting it, but somebody snitched on me and I only got a coupla miles away.

Normally you get mutilated for trying to make a break.

I should have ended up losing a hand, a foot, or at least some fingers.

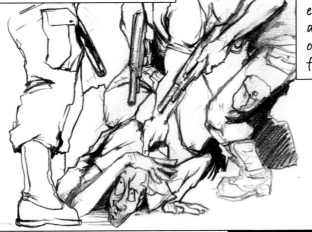

But what saved me was that Savior liked his entertainers in one piece.

Plus I groveled and grinned and groveled some more.

People sitting around in their armchairs, always talking a lot of number two about what they will or won't do...

Yeah sure. Well I brown-nosed and kissed ass a-plenty. And I haven't lost any sleep over it...not any. What the hell. That's why Listerine was invented.

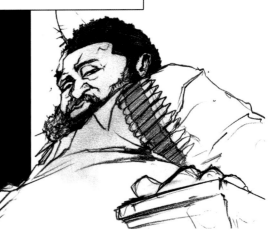

I wanted to see Rita again, preferably in the flesh, preferably in one piece. Not through some medium staring into some crystal ball doing the talking for me.

I laid in the cut for three years, until things cooled down. Then I tried a second time.

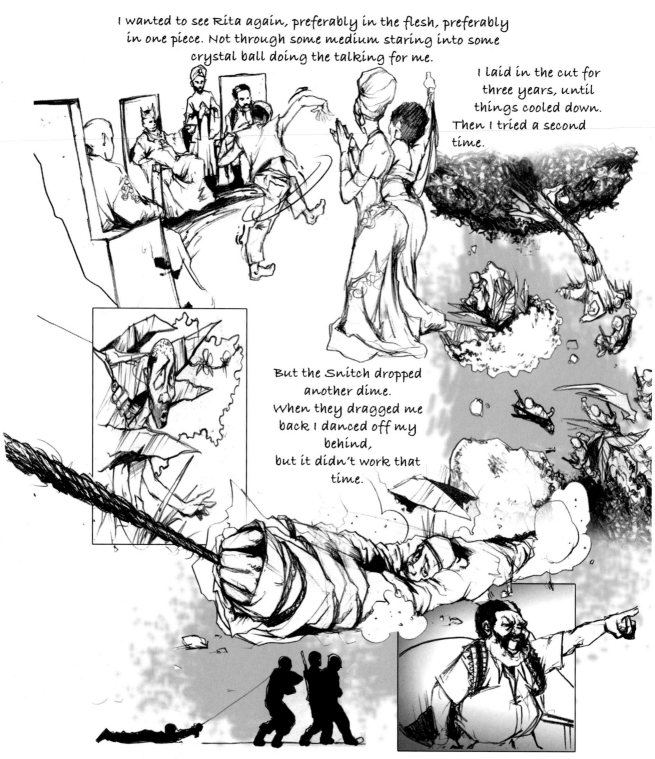

But the Snitch dropped another dime.
When they dragged me back I danced off my behind,
but it didn't work that time.

The Savior was so pissed he lost his Oxford accent and started getting down in his tribal tongue...all about my ungrateful behind having to SUFFER...and he FedExed my butt off to the mineral mines.

The mineral mines were the pits...the absolute PITS!
Chain gang, stone quarry, concentration camp,
cotton fields all mixed!
They'd beat you, mistreat you, work you to the bone.
For convenience sake, all us slave-diggers were labeled
heathens.

But Rita kept me
breathing...Getting
back to Rita is
what kept me
holding on.

Speaking of
believing, I did
something I'd
swore I'd never
ever do.

Funny how long "never" can get to be
when somebody is stomping on you.
I called on the big guy upstairs. That's
right...prayed...I prayed.

Anyhow, while I was waiting for the Lord,
"His wonders to perform," I had time to think
back and figure out who the snake-in-the-
entourage was, the Uncle Tom who kept
snitching on me whenever I tried to escape.

Years passed...ten of them.

Meantime, Savior's army was conquering the countryside.
When they were in spitting distance, a hundred miles or so from the ocean,
he decided it was time to play the potentate and have a big celebration.
He dispatches some soldiers to see if I'm still breathing.

"BINGO, DO JESUS!" just like the ole folks say,
"He may not come when you call Him, but He's always right on time."

The party was on a plantation that The Savior's boys had recently overrun.
A sprawling ranch sitting on the edge of the jungle.
It was old-home week, everybody, Judas/Uncle Tom included, acted glad to see me.

I put on a mega show, but under my recent circumstances, I hadn't been keeping up with the latest dances.
I had to use some old-timey steps...What the hell, they were new to them.

Savior kept eyeing me, trying to decide if I'd learned my lesson. If I knew him, he was going to sleep on it, wait until the morning to make up his mind.

I didn't give a shit about his decision...I'd made mine.
I was getting into the wind before the night was finished.
It was "Now or never" and I was gonna take it...But without a head start, there was no way I could make it.

...Well all about Uncle Tom I'm going to tell, I'm taking the fifth on what I did.

Any further communiqués from him will be coming from Hell.

Dawn had come and gone and I'm still barreling across the ranch ...no end in sight.

Heading down a road that I heard leads to a highway, that I heard leads to a port.

What's faster than feet?
Wheels on a truck!
I was a sitting duck.

Running your butt off, head start included, can only do so much.

Of course, there was the jungle, it had plenty of cover. In fact it was even supposed to be a short cut, but the word was it was dangerous,

Some kinda wildlife preserve for endangered species or something...

What happened after that, the middle part is what I mean, I won't even go into.

I can't expect anyone to believe me...
I can't even believe it myself.

So I'll just cut to the chase...

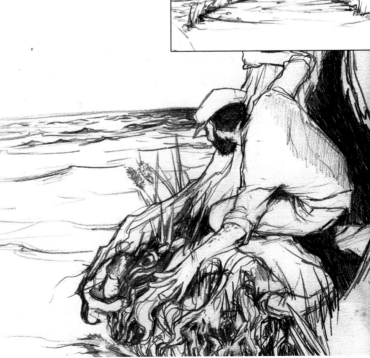

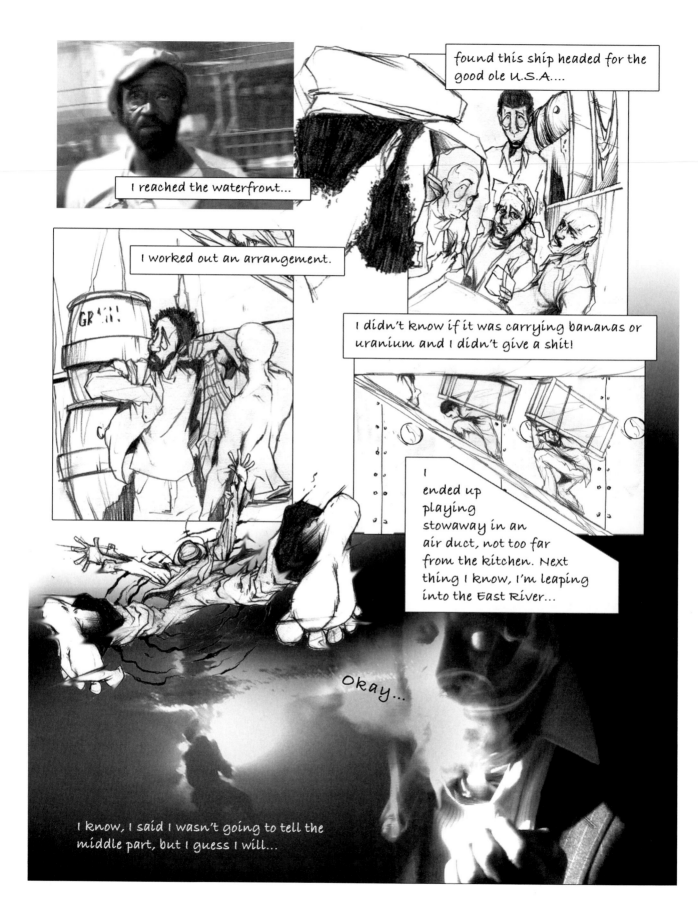

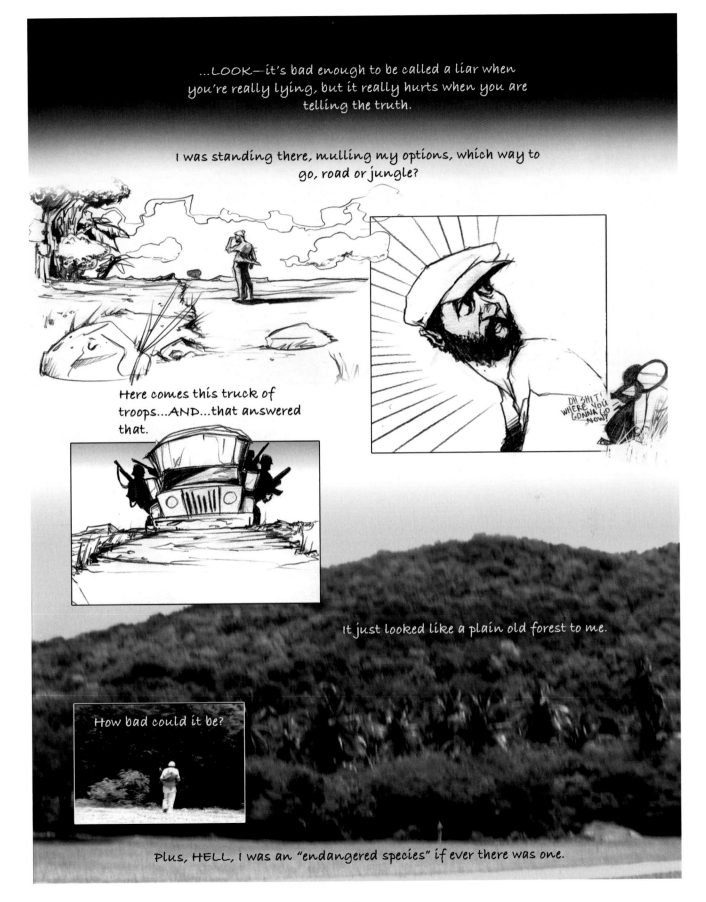

...LOOK—it's bad enough to be called a liar when you're really lying, but it really hurts when you are telling the truth.

I was standing there, mulling my options, which way to go, road or jungle?

Here comes this truck of troops...AND...that answered that.

OH SHIT! WHERE YOU GONNA GO NOW?

It just looked like a plain old forest to me.

How bad could it be?

Plus, HELL, I was an "endangered species" if ever there was one.

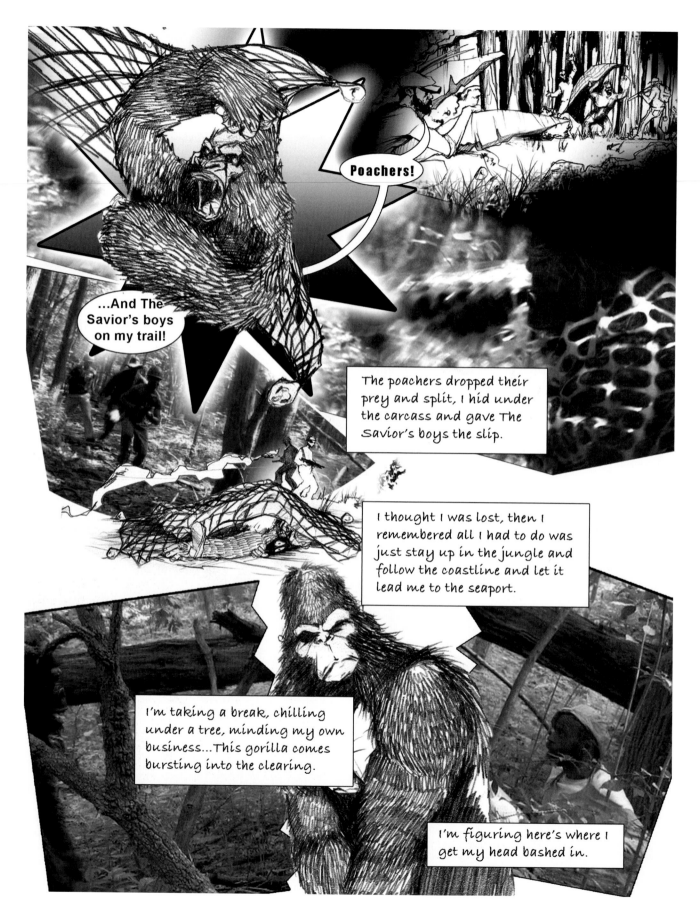

But instead he's got his love-jones going and comes wrapping his arms around me. Maybe they go by odor, maybe back there when I was dodging the soldiers, that was his girlfriend's hide I had hid under.

He starts giving me a bear hug.

A bear hug!...He's a damn gorilla for Godsake!

I had to do something... I start yanking his "G" spot, he starts getting all into it...

He starts to grin...I slip loose and get into the wind.

I heard footsteps behind me.

I looked around... He was beckoning me...

INVITING ME BACK...

...Anyhow, that's what it looked like to me.

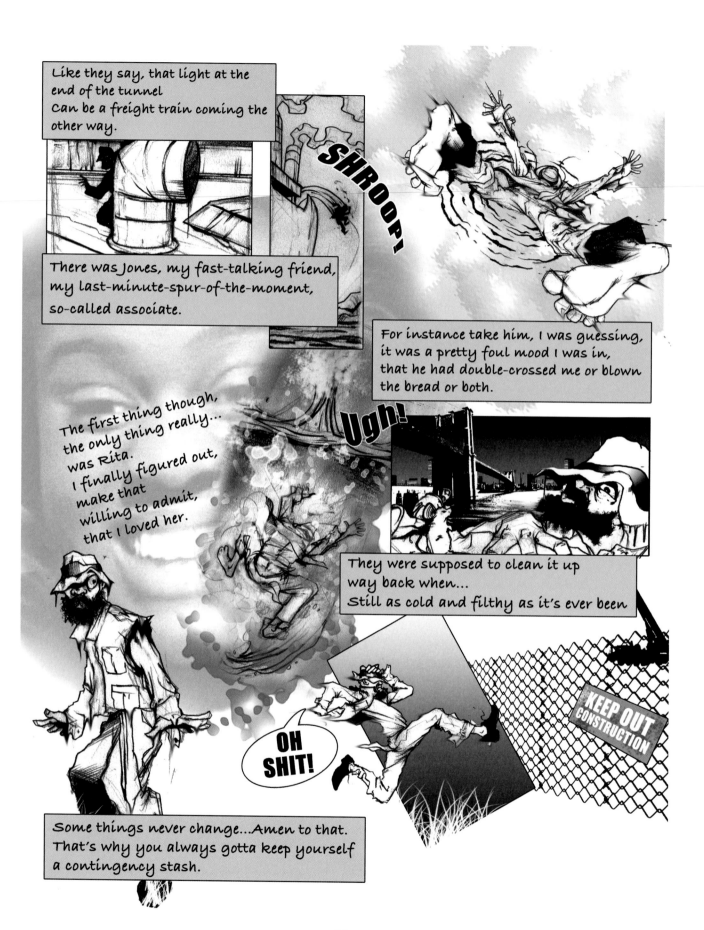

Like they say, that light at the end of the tunnel
Can be a freight train coming the other way.

SHROOP!

There was Jones, my fast-talking friend, my last-minute-spur-of-the-moment, so-called associate.

For instance take him, I was guessing, it was a pretty foul mood I was in, that he had double-crossed me or blown the bread or both.

The first thing though, the only thing really... was Rita. I finally figured out, make that willing to admit, that I loved her.

Ugh!

They were supposed to clean it up way back when...
Still as cold and filthy as it's ever been

OH SHIT!

KEEP OUT CONSTRUCTION

Some things never change...Amen to that. That's why you always gotta keep yourself a contingency stash.

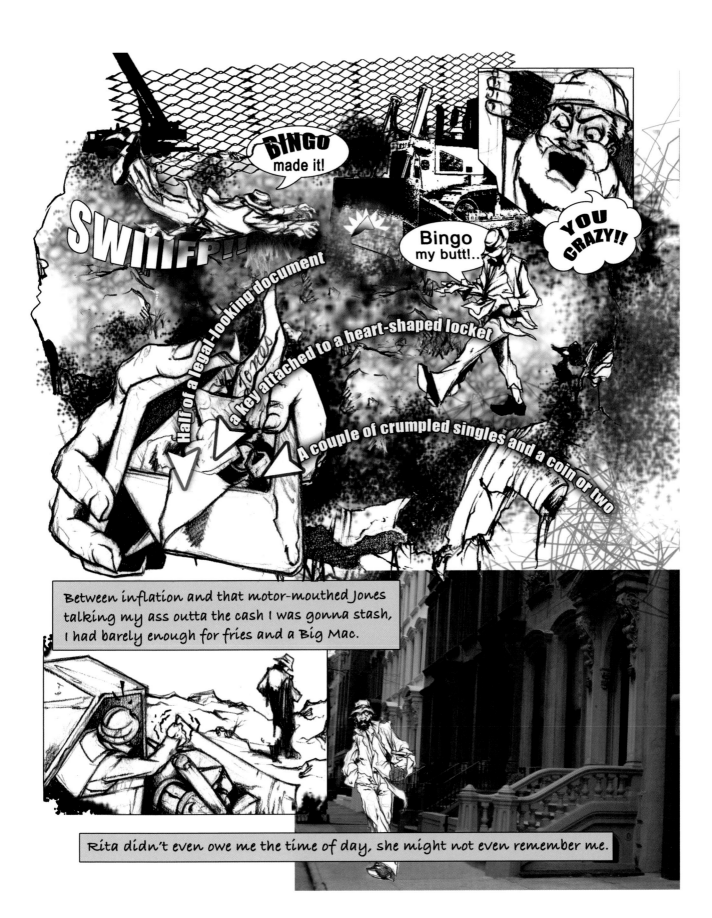

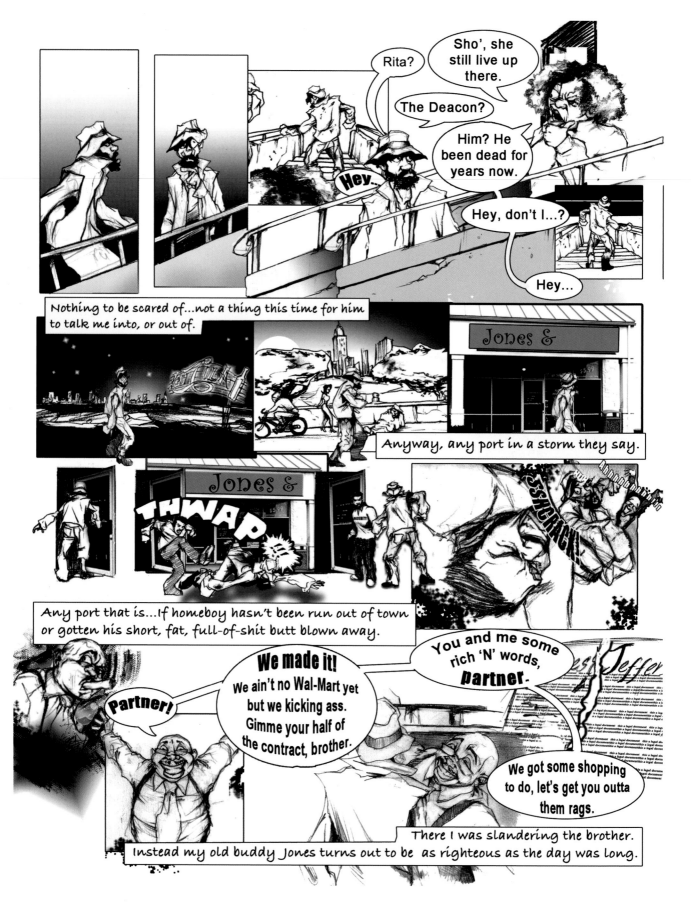

Okay...Since that moment, in that glen tied to that tree, I've been waiting for this moment. How many hours has it been?

Okay...So how come I'm still sitting here then? When I peed my pants, was it because I was scared, or was it like I've been telling myself all these years, because I was grief-stricken over never seeing her again...

Either way...

...Either damn way... Here I go...

It's a long climb back from being a fool.

Steps seem awful steep when you got some crow to eat.

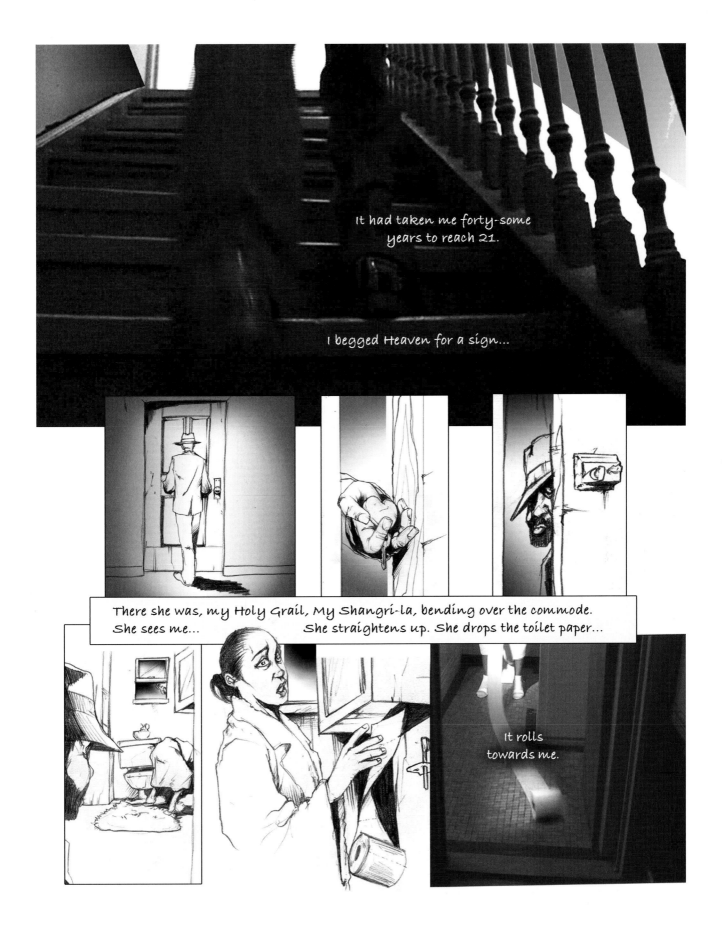

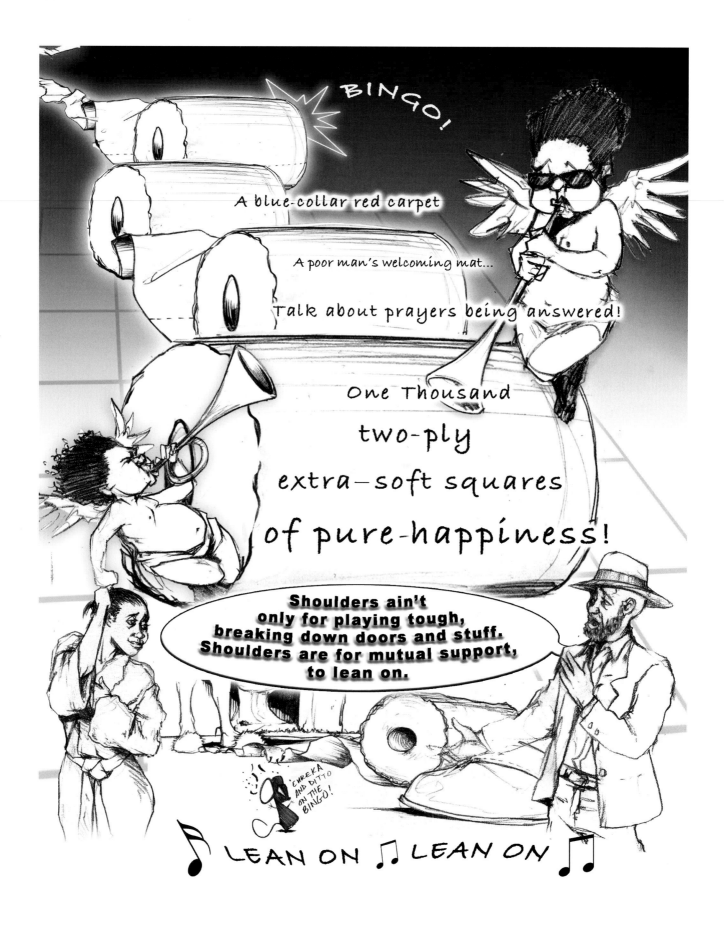

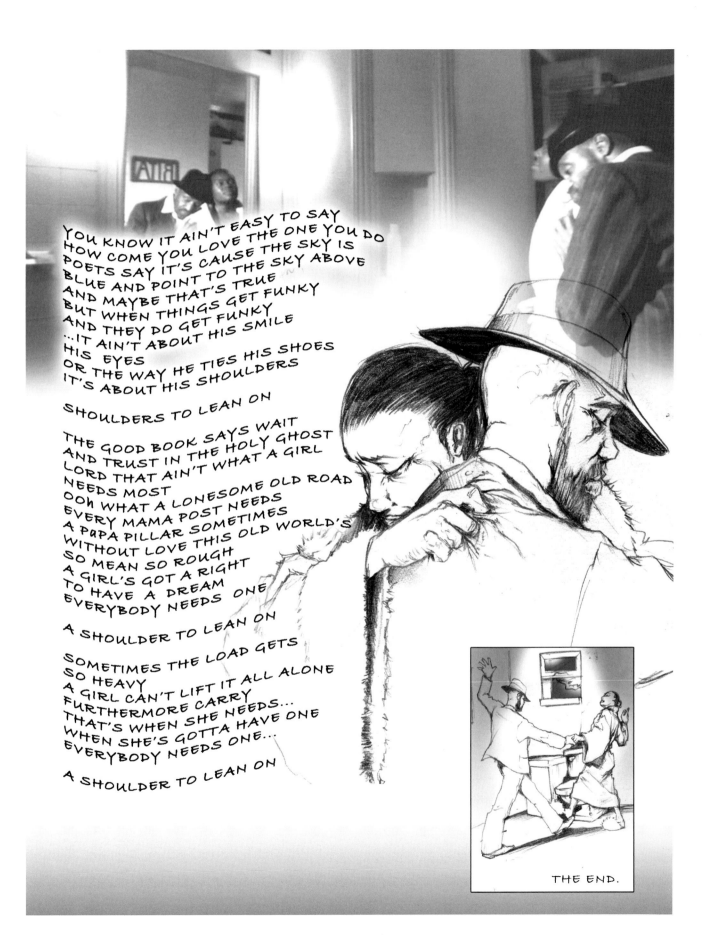

YOU KNOW IT AIN'T EASY TO SAY
HOW COME YOU LOVE THE ONE YOU DO
POETS SAY IT'S CAUSE THE SKY IS
BLUE AND POINT TO THE SKY ABOVE
AND MAYBE THAT'S TRUE
BUT WHEN THINGS GET FUNKY
AND THEY DO GET FUNKY
...IT AIN'T ABOUT HIS SMILE
HIS EYES
OR THE WAY HE TIES HIS SHOES
IT'S ABOUT HIS SHOULDERS

SHOULDERS TO LEAN ON

THE GOOD BOOK SAYS WAIT
AND TRUST IN THE HOLY GHOST
LORD THAT AIN'T WHAT A GIRL
NEEDS MOST
OOH WHAT A LONESOME OLD ROAD
EVERY MAMA POST NEEDS
A PAPA PILLAR SOMETIMES
WITHOUT LOVE THIS OLD WORLD'S
SO MEAN SO ROUGH
A GIRL'S GOT A RIGHT
TO HAVE A DREAM
EVERYBODY NEEDS ONE

A SHOULDER TO LEAN ON

SOMETIMES THE LOAD GETS
SO HEAVY
A GIRL CAN'T LIFT IT ALL ALONE
FURTHERMORE CARRY
THAT'S WHEN SHE NEEDS...
WHEN SHE'S GOTTA HAVE ONE
EVERYBODY NEEDS ONE...

A SHOULDER TO LEAN ON

THE END.